DAVID BOWIE
retrospective and
coloring book

DAVID BOWIE
retrospective and
coloring book

Mel Elliott

WATSON-GUPTILL PUBLICATIONS
Berkeley

Introduction

In 1947, David Jones was born in Brixton, London. As a child, his singing voice landed him a spot in the school choir. Later, this very same voice would become one of the most recognizable sounds in music for almost fifty years.

Due to his voice, his innovative music, his creative artistry, and his memorable costumes, David Bowie became an icon of British and worldwide pop culture.

His look has influenced countless fashion designers, and his makeup has been copied by models, singers, and pretty much everyone who's ever been to a fancy-dress party. Here he rocks his famous off-the-shoulder blue-flame unitard. Figure-hugging and flamboyant, it's a look only Bowie could carry off.

This book is a tribute to a man whose work has meant so much to so many people. It is also a celebration of the many guises taken on by the most colorful and unique master of pop and rock.

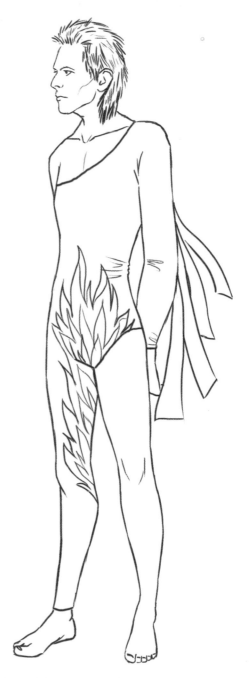

Designed by Kansai Yamamoto, 1973

In September 1965, a young David Jones became David Bowie and, in 1967, he released his first solo, self-titled album.

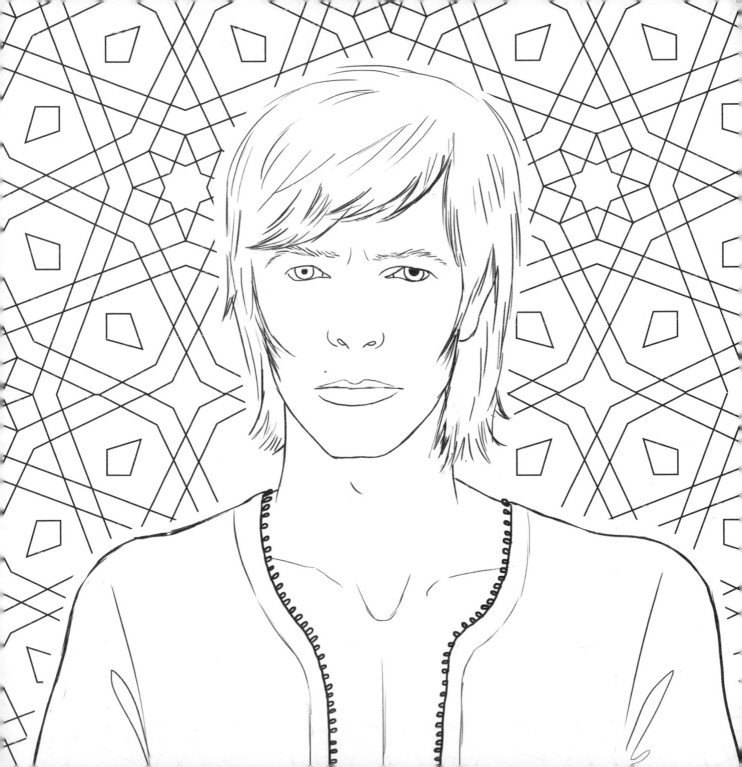

By 1969, his hair had taken on the Bob Dylan look—and Bowie later penned a song about him.*

*"Song for Bob Dylan," 1971, featured on the *Hunky Dory* album.

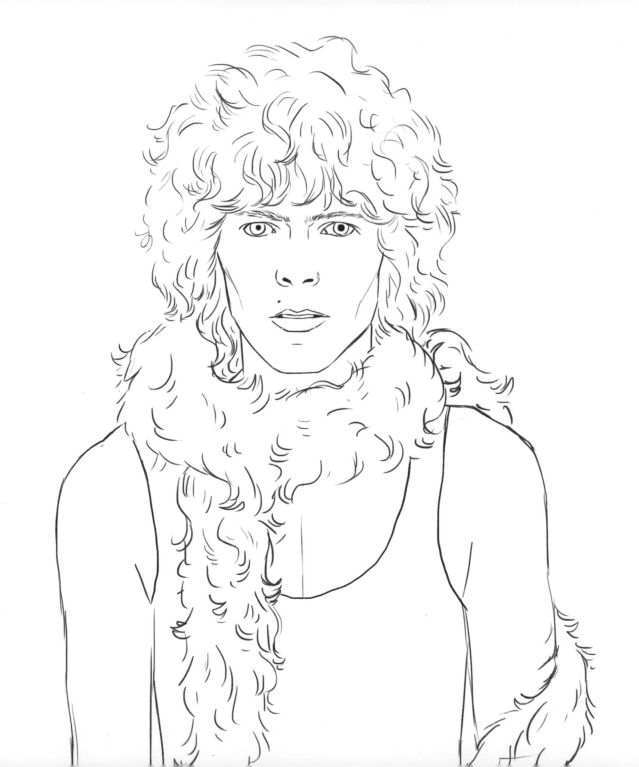

But it was in 1973 that David Bowie adopted one of his most iconic and copied looks. Aladdin Sane was born.

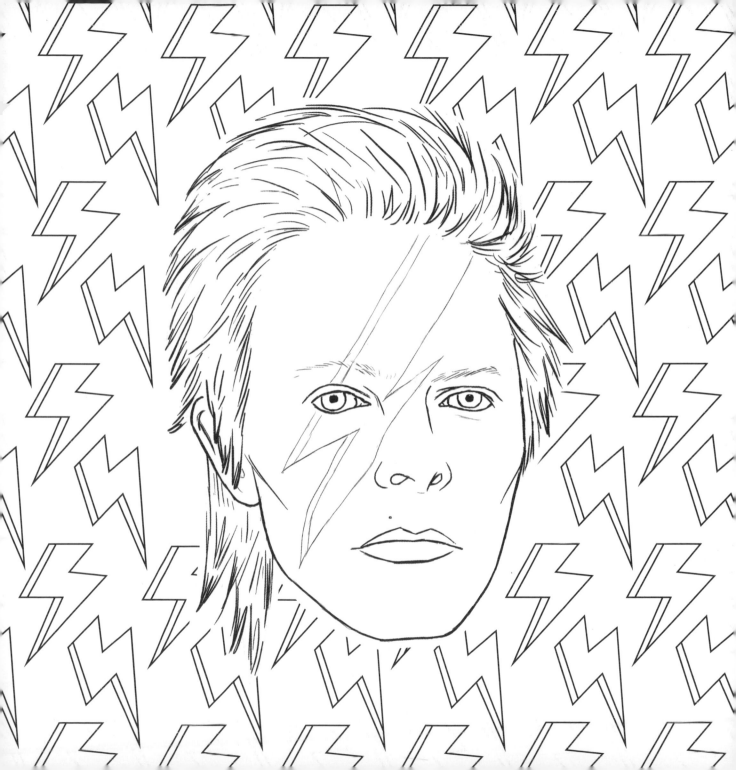

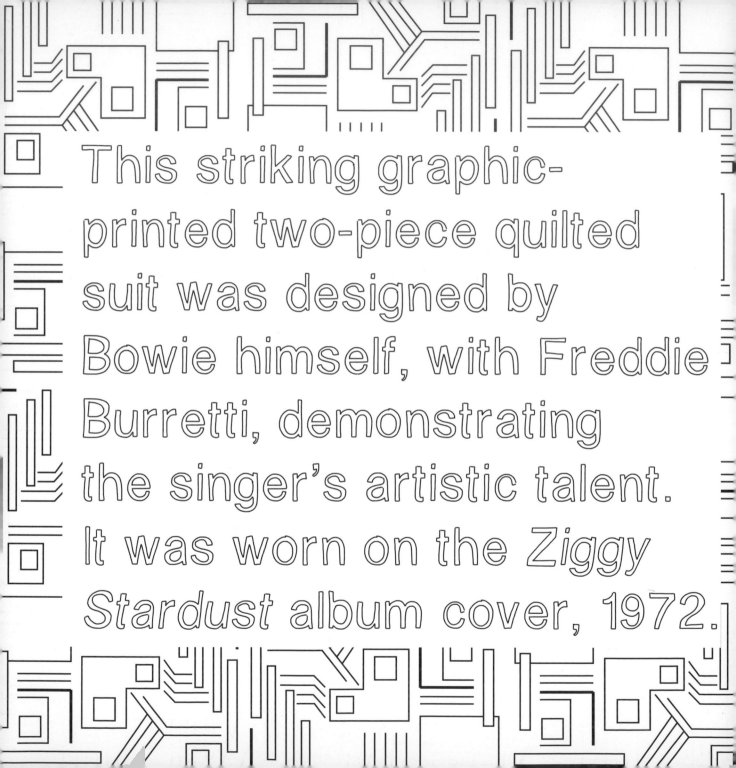

This striking graphic-printed two-piece quilted suit was designed by Bowie himself, with Freddie Burretti, demonstrating the singer's artistic talent. It was worn on the *Ziggy Stardust* album cover, 1972.

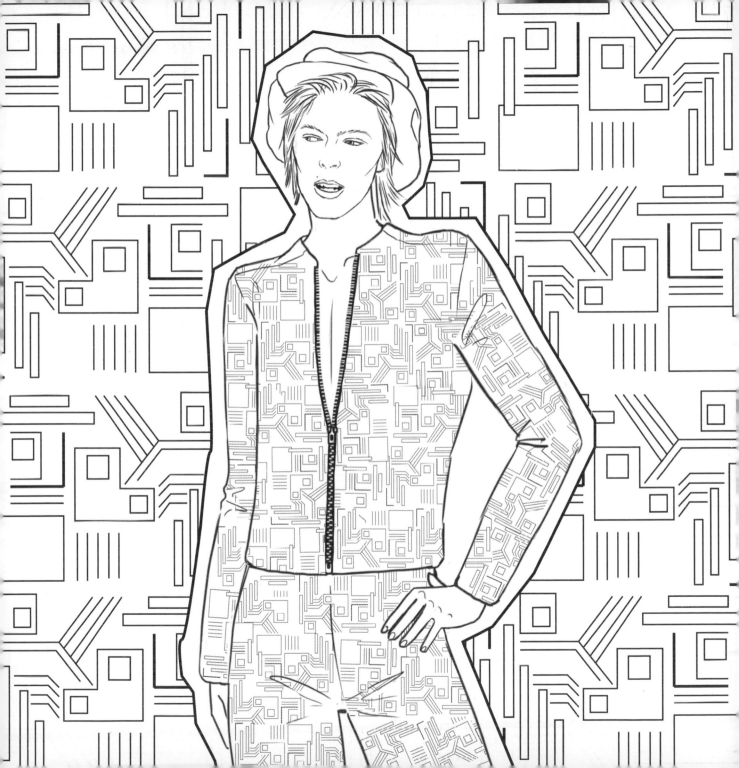

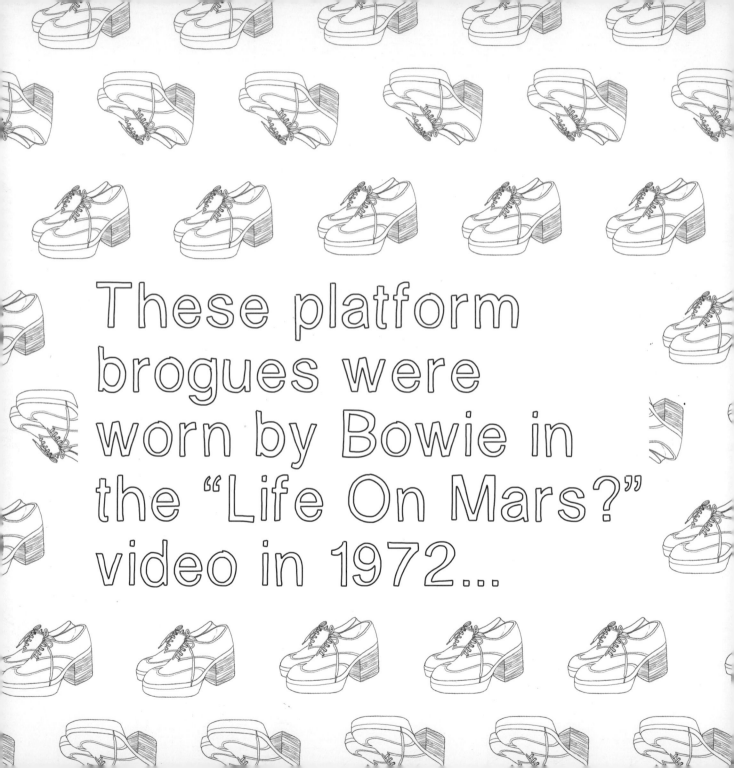

These platform brogues were worn by Bowie in the "Life On Mars?" video in 1972...

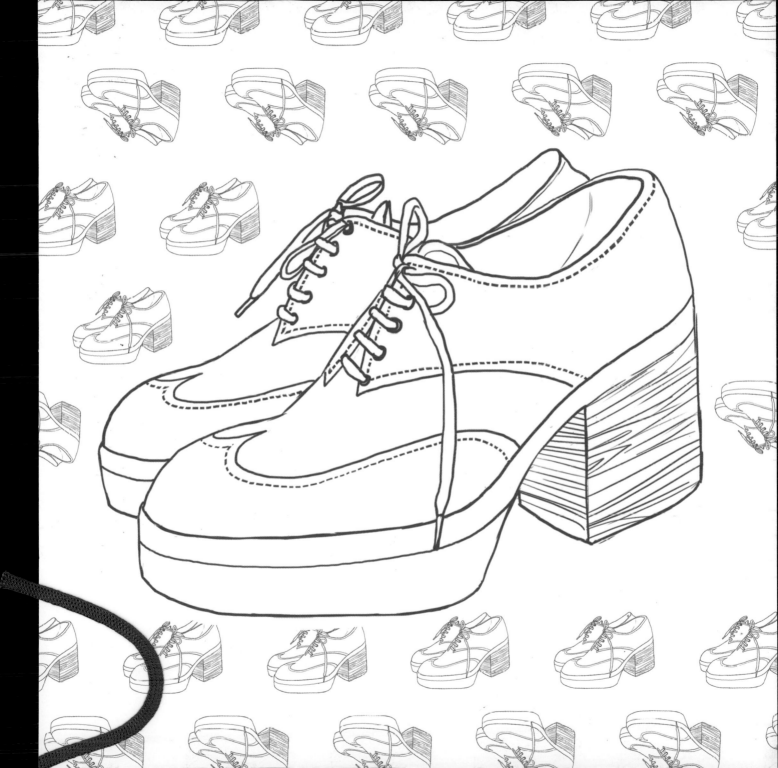

...along with this iconic ice-blue suit by Freddie Burretti (later worn by Kate Moss during a *British Vogue* shoot). The color dramatically contrasted with Bowie's bright red hair and matched his eye shadow.

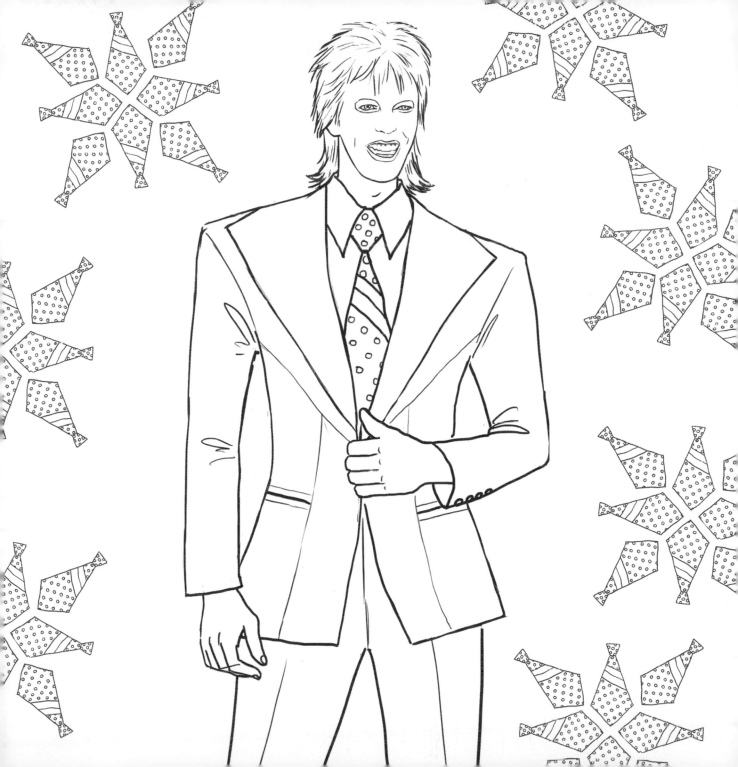

This famous, magical "rabbit suit" was used on the *Ziggy Stardust* tour in 1972. Designed by Kansai Yamamoto, it was worn by Kate Moss when she collected a Brit award on Bowie's behalf.

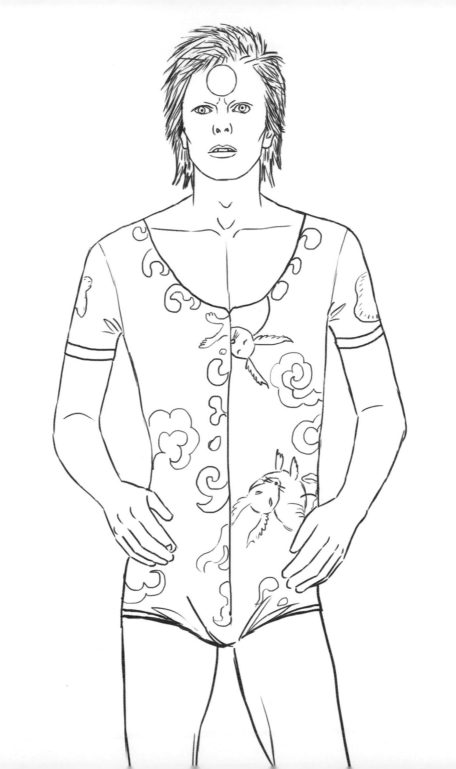

Ziggy Stardust wore this striped "power" suit with origami-inspired shoulders for his farewell concert at the Hammersmith Odeon in 1973. It was also designed by Yamamoto.

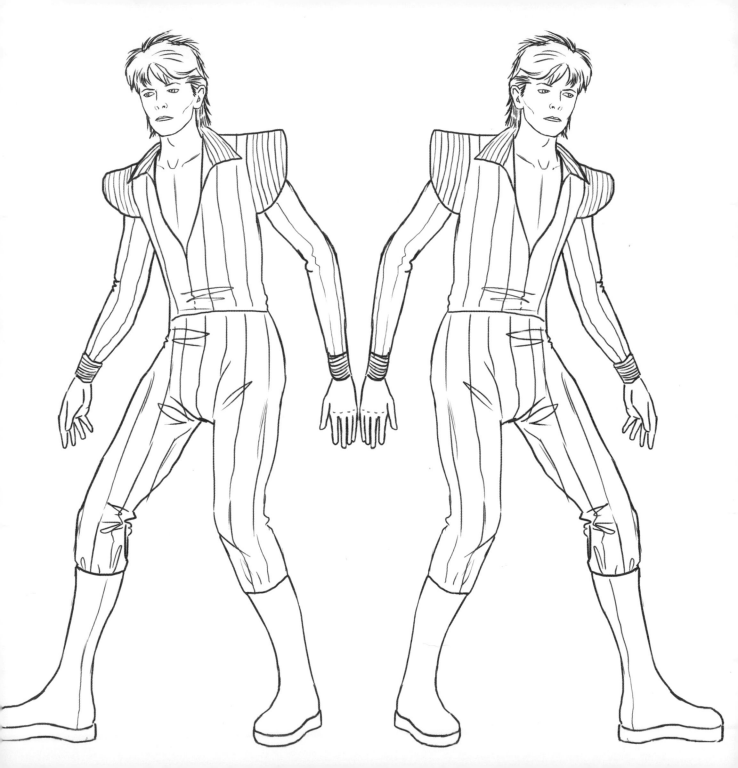

This striking vinyl bodysuit was also designed by Kansai Yamamoto for Aladdin Sane. Bowie was fascinated by all things Japanese, and this design was particularly suited to his androgynous style.

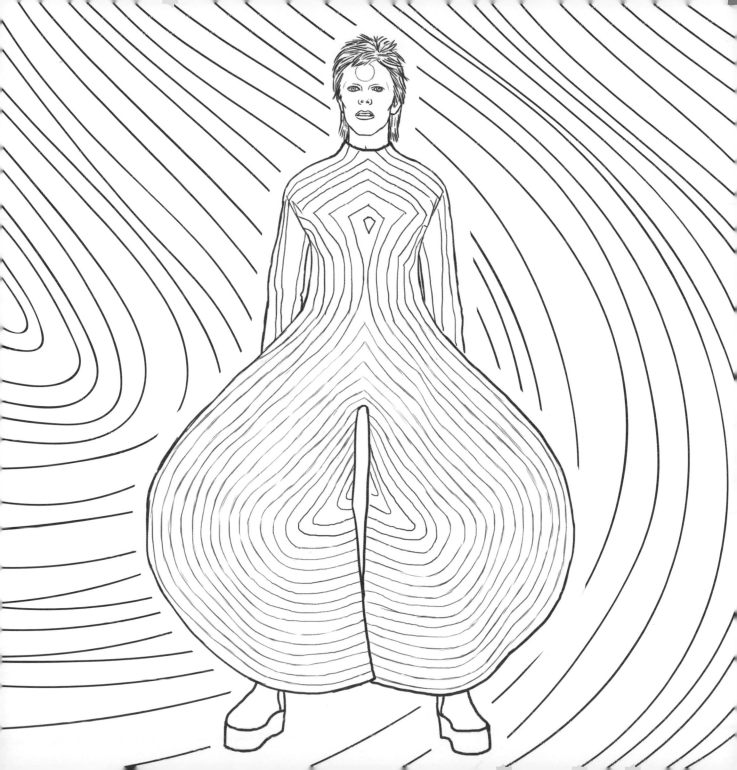

Another asymmetric, androgynous dance-inspired bodysuit was designed by Kansai Yamamoto for Bowie while he was touring for *Aladdin Sane* in 1973.

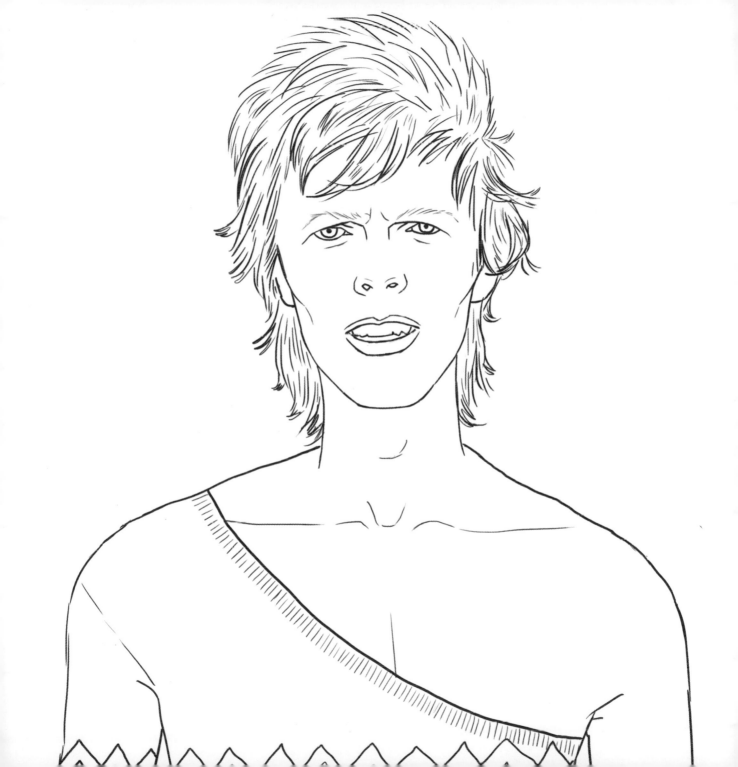

This knitted, patterned bodysuit, cleverly balanced despite its asymmetric form, sat perfectly on Bowie's lean frame.

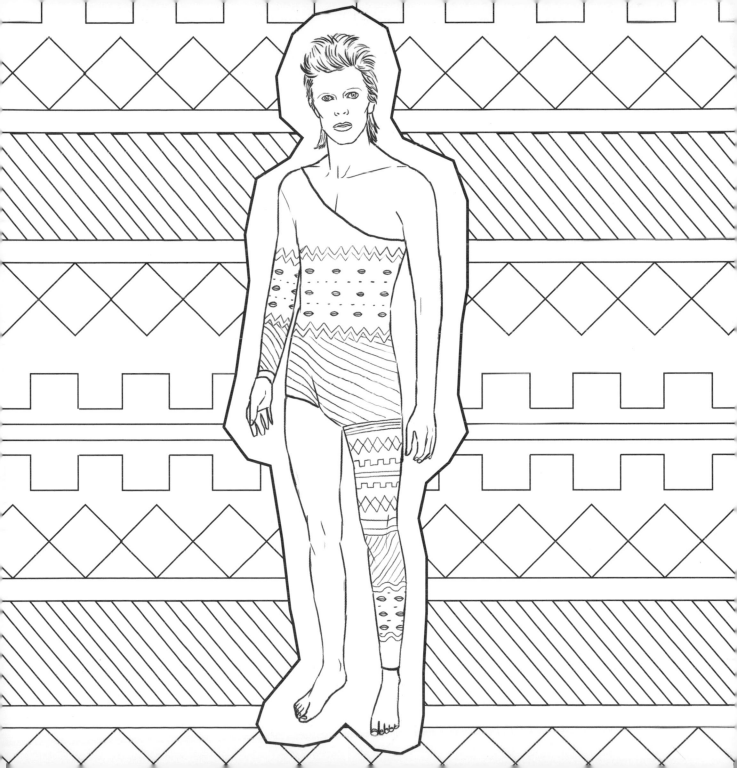

The stripes in this metallic suit by Kansai Yamamoto for Aladdin Sane in 1973 echo his famous lightning-bolt makeup.

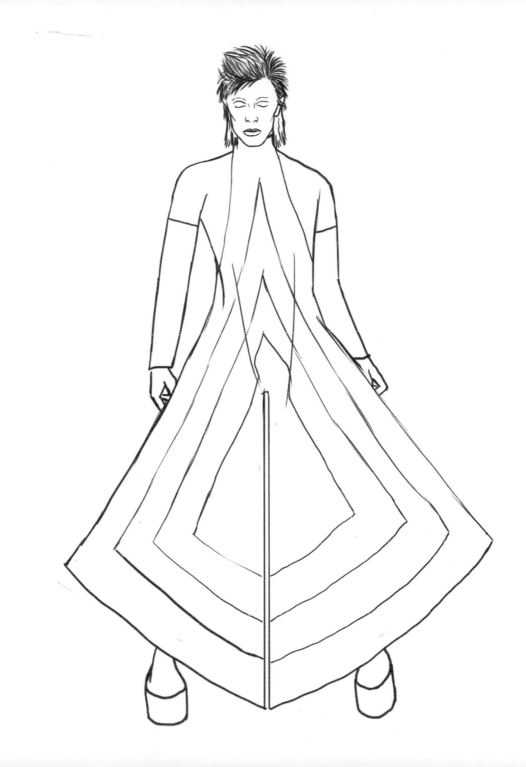

1974 and the *Diamond Dogs* album heralded a change. Elegant, dapper, and sensual in a Spanish Cordoba hat, high-waisted gaucho pants, and platform boots, Bowie was abandoning bizarre glitz in favor of a more classic style.

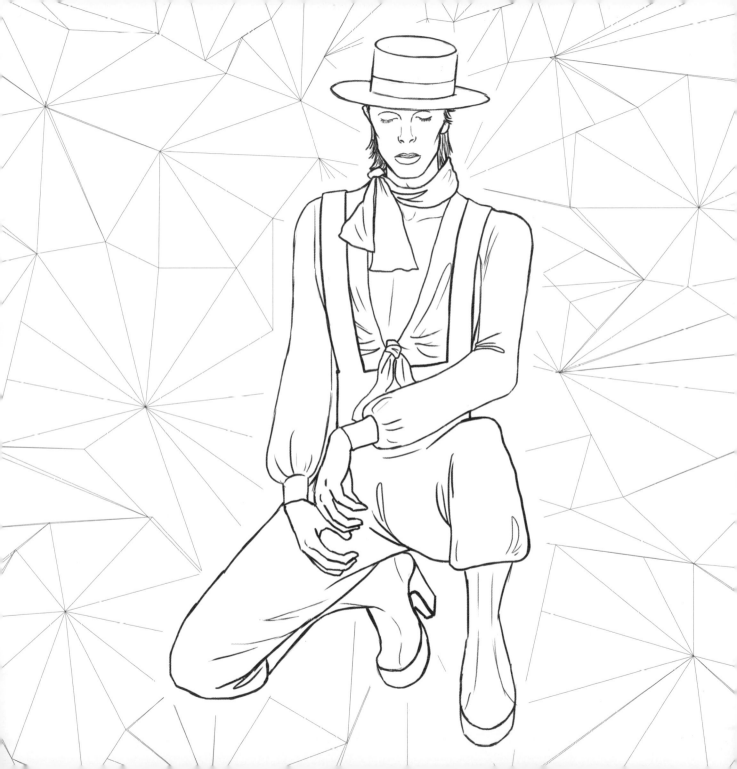

Another twist on the classic, traditional style was this double-breasted suit with suspenders, designed by Freddie Burretti in 1974.

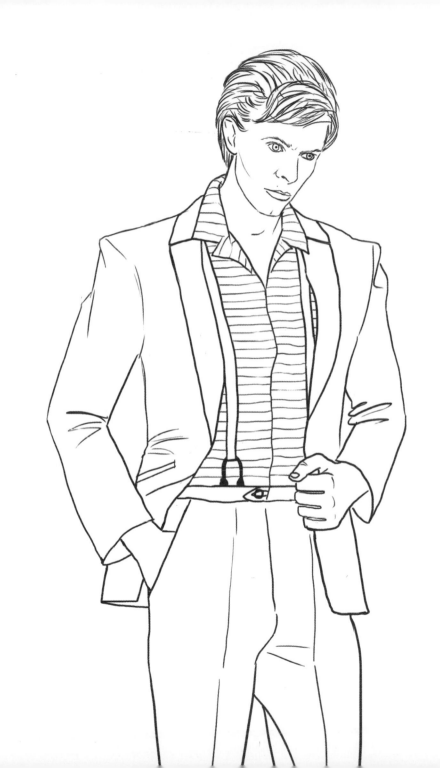

Rebel rebel!
In 1976, Bowie was
arrested along with Iggy
Pop for possession of
marijuana in Rochester,
New York.

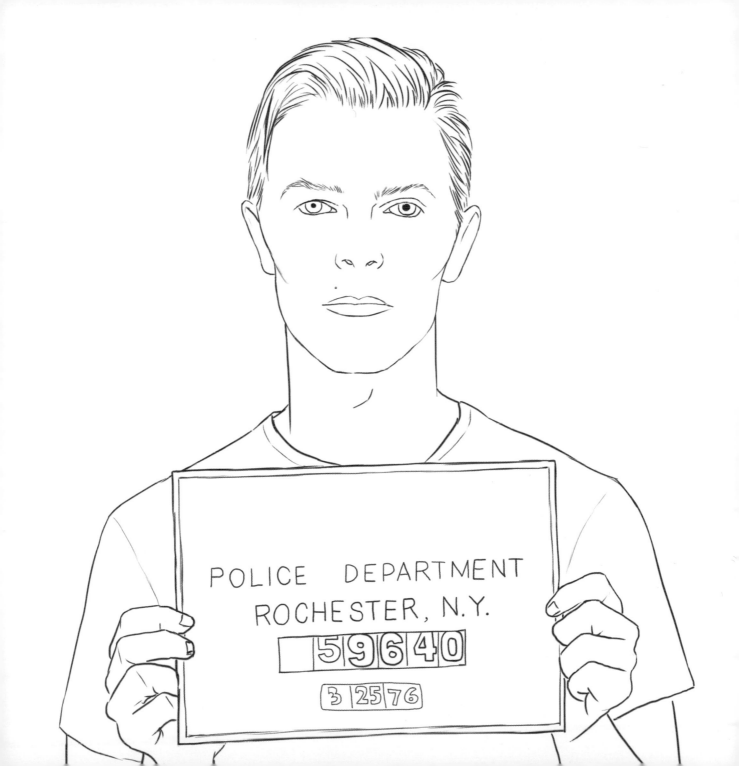

This whimsical, fanciful costume, designed by Natasha Korniloff for the "Ashes to Ashes" video, shows Bowie dressed as a romantic yet melancholy "blue clown."

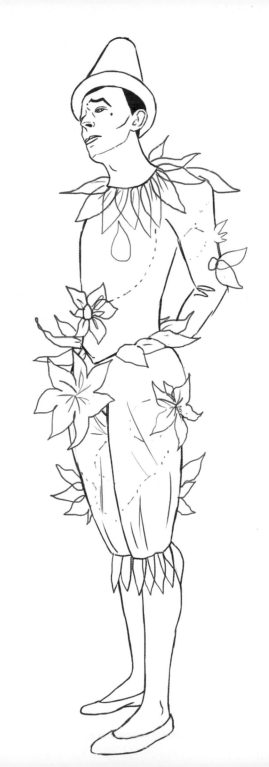

Bowie kept himself incredibly busy in the 1980s with huge hits like *Ashes to Ashes*, *Fashion*, *Modern Love*, and, my absolute favorite, *Absolute Beginners*.

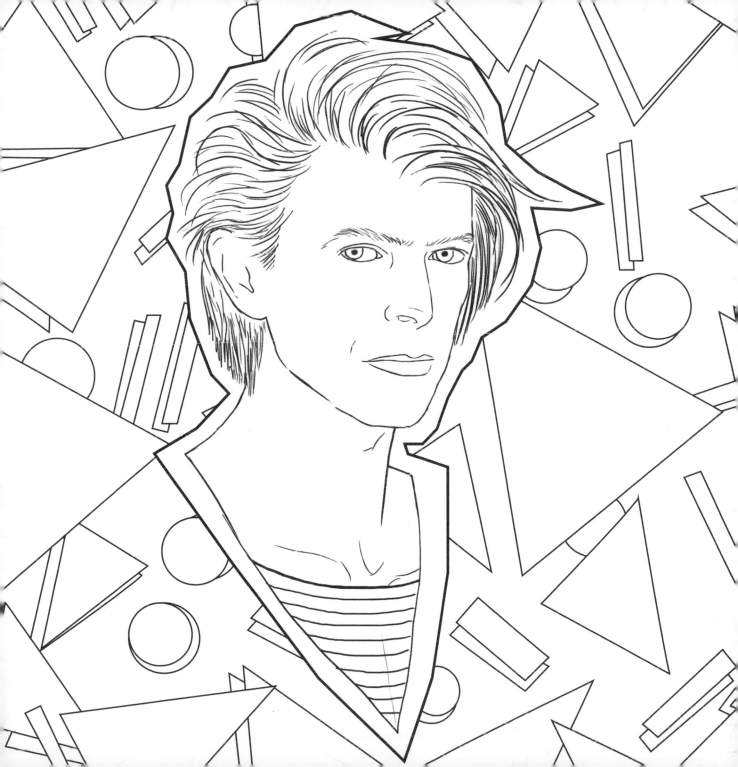

This cobweb costume, designed by Natasha Korniloff in 1973, didn't leave much to the imagination. The black netting and the appliqué gold hands make this an iconic outfit.

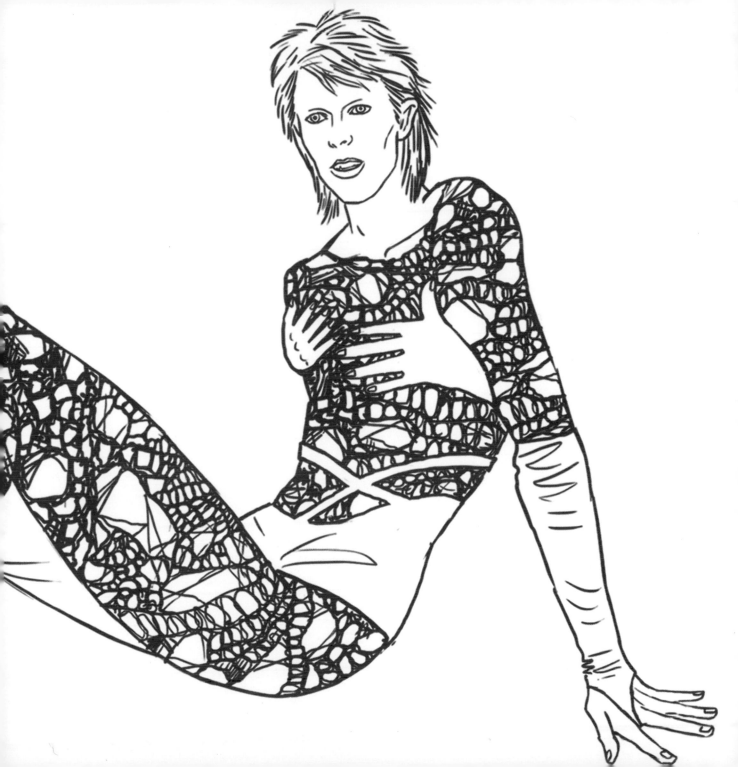

This loose, relaxed, double-breasted suit resembles a pair of pajamas. It was designed by Peter Hall for the *Serious Moonlight Tour* in 1983. Bowie's short hair and undone bow tie are a nod to a more traditional era.

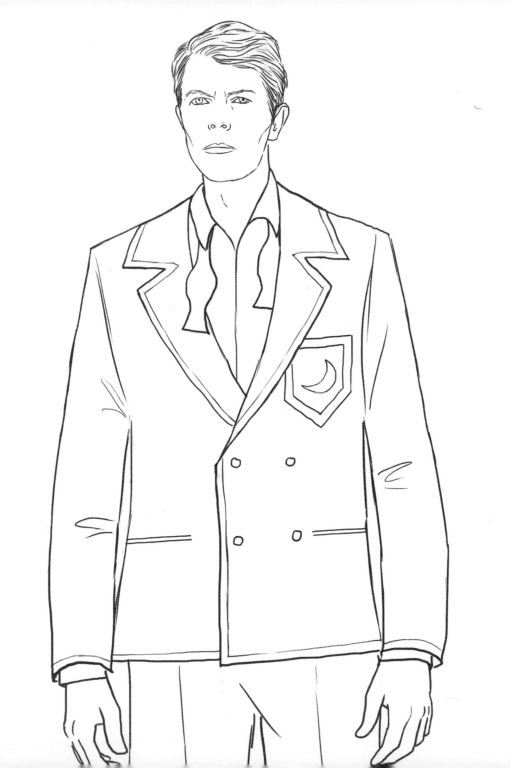

Bowie released duets with not one, not two, not three, but FOUR people in the 1980s: Mick Jagger, Bing Crosby, Tina Turner, and Freddie Mercury of Queen!

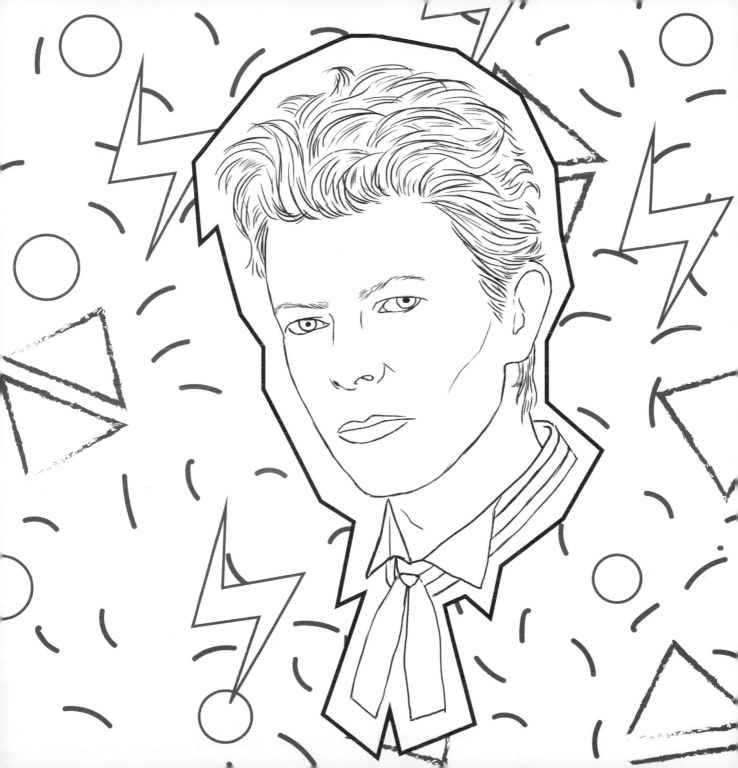

He also starred in the 1986 hit movie *Labyrinth*, directed by Jim Henson.

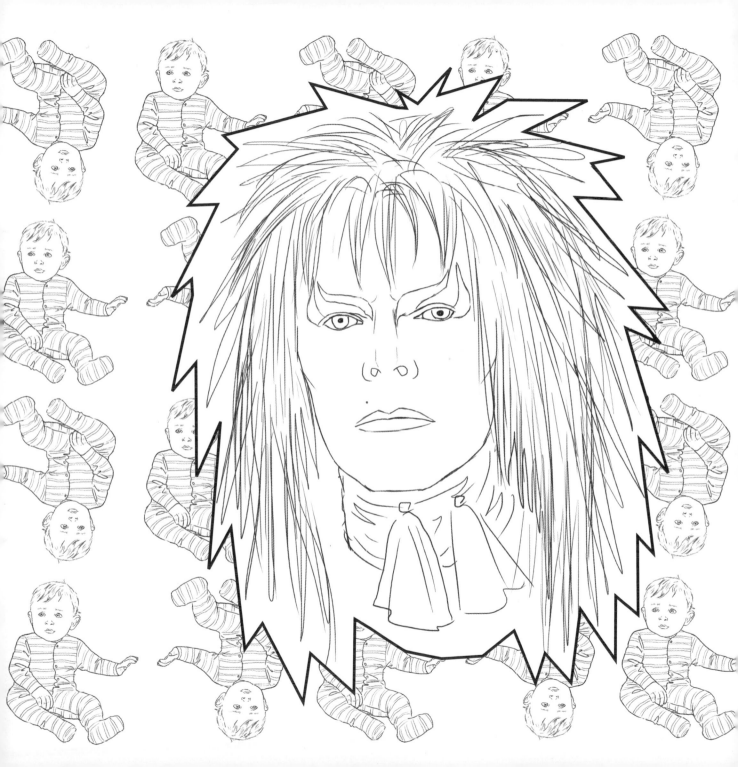

David BOWIE

would sometimes CUT

up song

lines

and REARRANGE them

to create

NEW lyrics.

In 1996, Bowie collaborated with Alexander McQueen with this patriotic Union Jack frock coat. McQueen distressed the fabric to give it more character and a vintage feel.

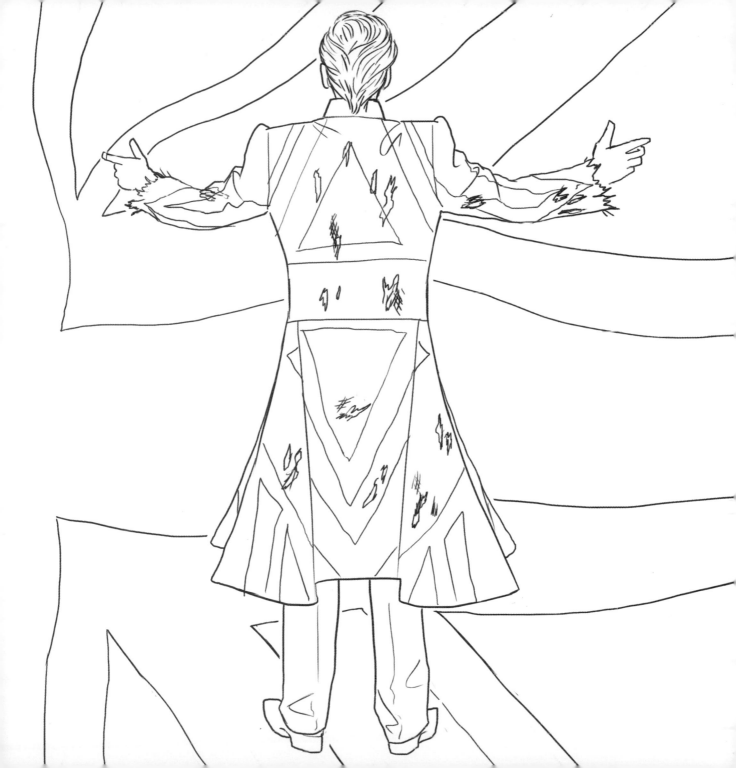

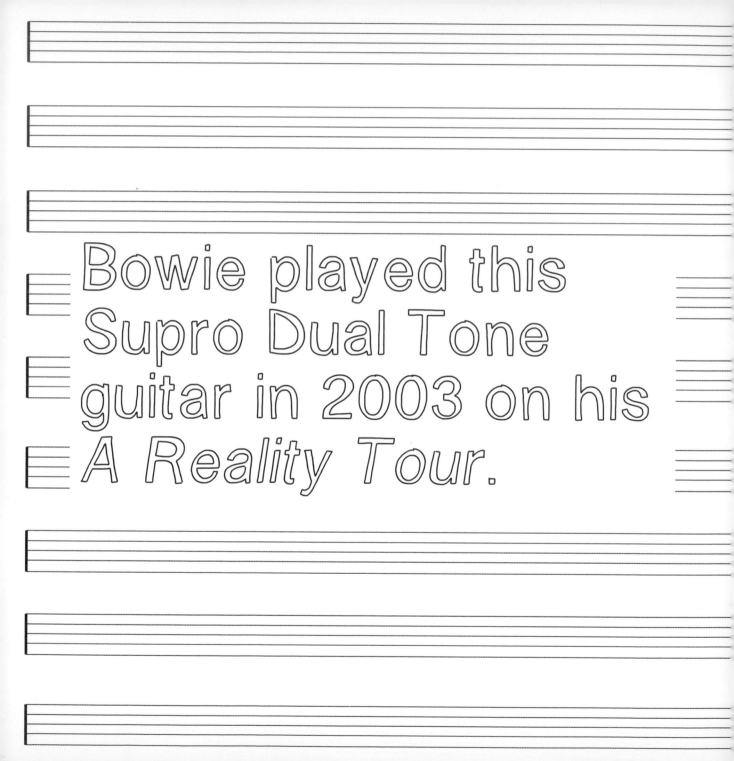

Bowie played this Supro Dual Tone guitar in 2003 on his *A Reality Tour*.

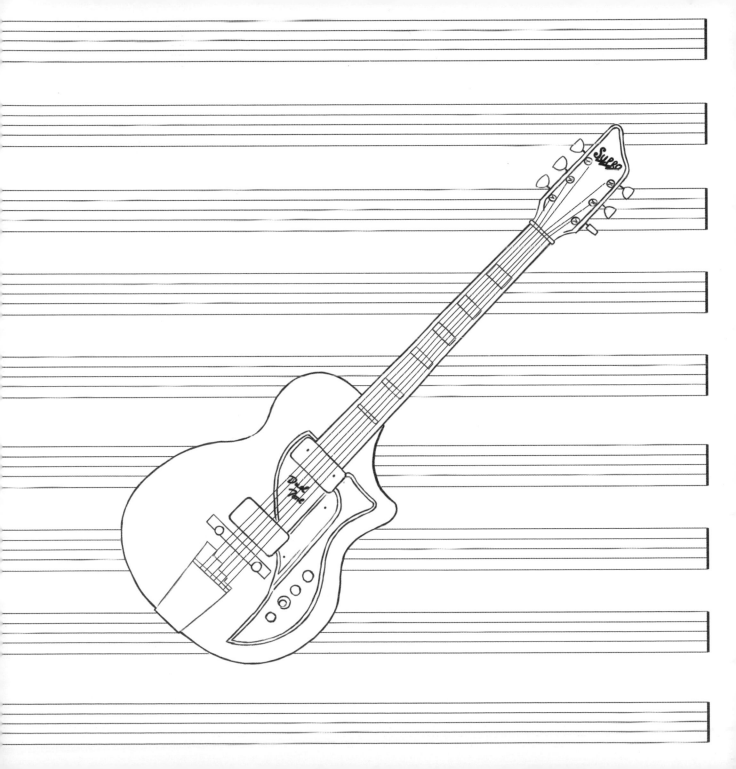

In the early 2000s, Bowie's look had become less wild. However, his popularity hadn't. In 2003, Bowie posed alongside Kate Moss for *Q Magazine*, shot by renowned photographer Ellen von Unwerth.

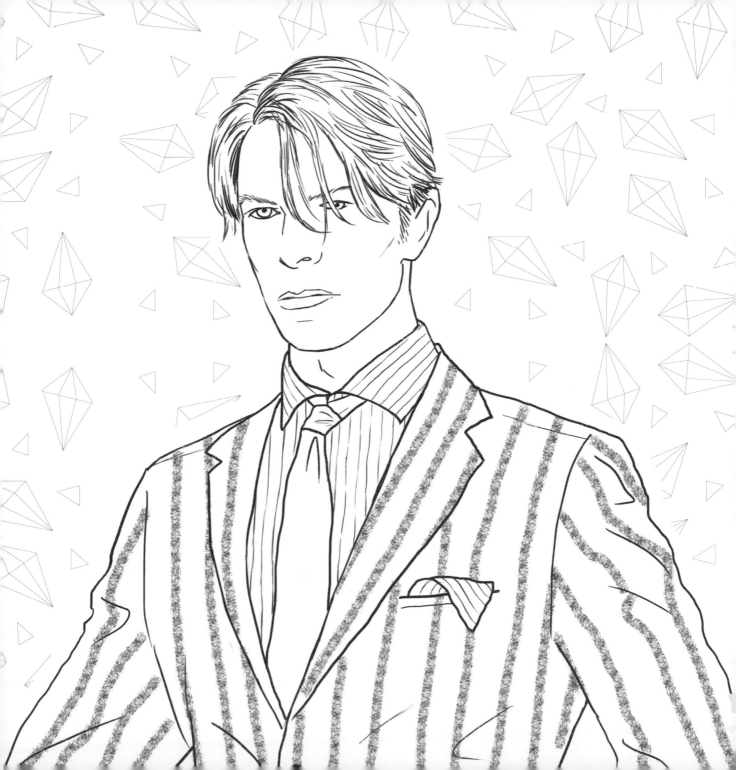

When not performing, Bowie's attire would be slightly more down-to-earth but would always remain incredibly stylish. He was often photographed wearing a trilby or fedora hat and regularly wore one all through the 1970s and right up until his death in 2016.

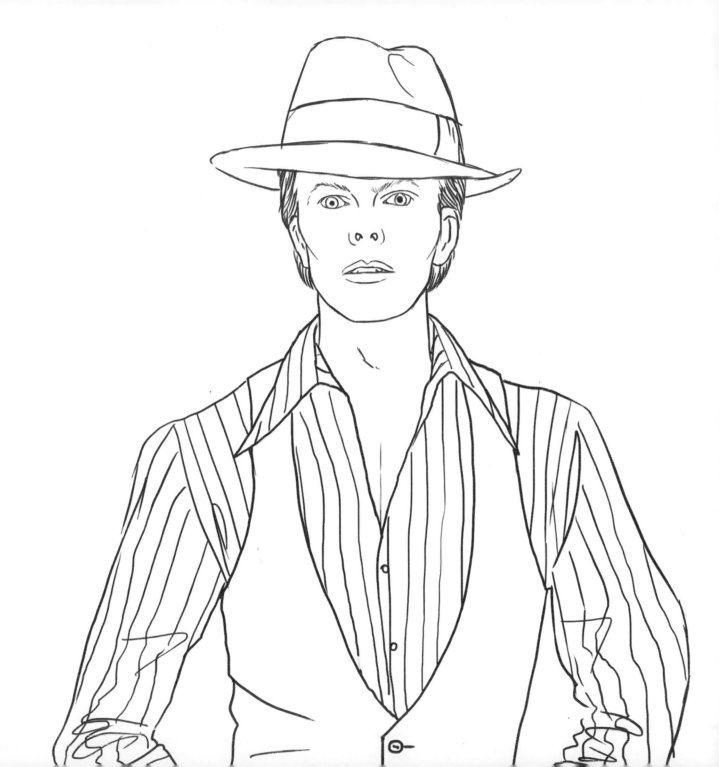

Bowie continued to impress fans with innovative music up until the end. With his 2016 album *Blackstar*, he solidified his place as one of the most creative and forward-thinking musicians and artists that this world has ever known.

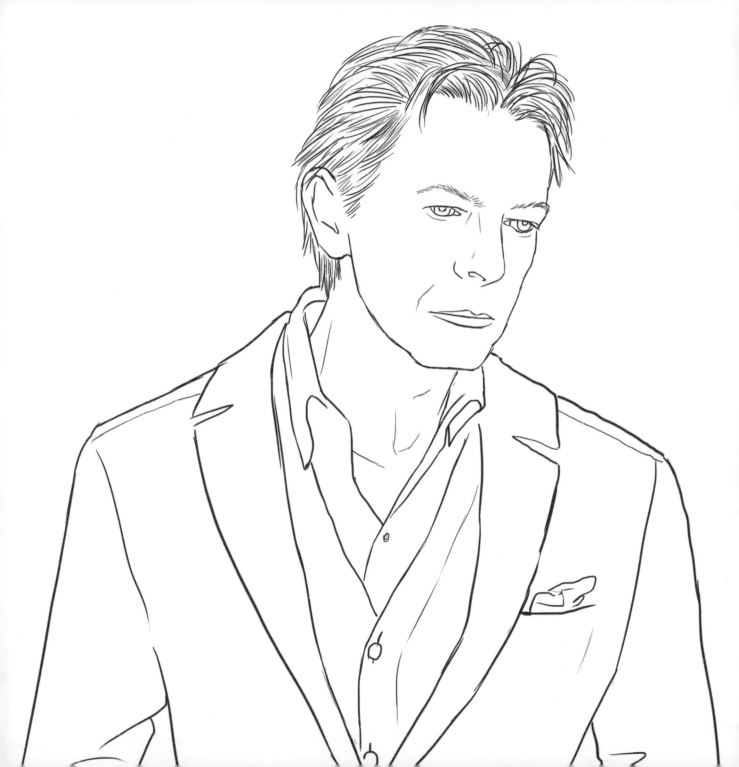

Discography (albums)

1967	David Bowie	Deram
1969	David Bowie Man of Words/Man of Music	Philips, Mercury
1970	The Man Who Sold the World	Mercury
1971	Hunky Dory	RCA
1972	Space Oddity	RCA
1972	The Rise and Fall of Ziggy Stardust and the Spiders from Mars	RCA
1973	Aladdin Sane	RCA
1973	Pinups	RCA
1974	Diamond Dogs	RCA
1975	Young Americans	RCA
1976	Station to Station	RCA
1977	Low	RCA
1977	"Heroes"	RCA
1979	Lodger	RCA
1980	Scary Monsters (and Super Creeps)	RCA
1983	Let's Dance	EMI
1984	Tonight	EMI
1987	Never Let Me Down	EMI
1989	Tin Machine	EMI
1991	Tin Machine II	London
1993	Black Tie White Noise	Savage Records, Arista
1995	1. Outside	Arista, BMG
1997	Earthling	RCA
1999	'Hours...'	Virgin
2002	Heathen	ISO/Columbia
2003	Reality	ISO/Columbia
2013	The Next Day	ISO/Columbia
2016	Blackstar	ISO/Columbia

Selected Awards

1969	Ivor Novello Special Award for Originality for "Space Oddity"
1974	NME Award for British Male Singer
1977	Saturn Award (Academy of Science Fiction, Fantasy, and Horror Films, USA) for Best Actor in *The Man Who Fell To Earth*
1983	NME Award for Best Dressed Male
1984	MTV Video Music Award for Best Male Video for "China Girl"
1984	Brit Award for Best British Male
1985	Grammy Award for Best Music Video for "Jazzin' for Blue Jean"
1986	MTV Music Video Award for "Dancing in the Street"
1995	Q Inspiration Award
1996	Brit Award for Outstanding Contribution to British Music
1997	Star on the Hollywood Walk of Fame
1998	MuchMusic Video EyePopper Award for "I'm Afraid of Americans"
1999	Commander of the Order of Arts and Letters, France
2000	GQ Award for Most Stylish Man of the Year
2003	Daytime Emmy Award for Outstanding Special Class Special, for "Hollywood Rocks the Movies: The 1970s"
2006	Grammy Lifetime Achievement Award
2007	Webby Lifetime Achievement Award
2014	Brit Award for Best British Male
2016	NME Award for Best Reissue, "Five Years" (1969–1973)

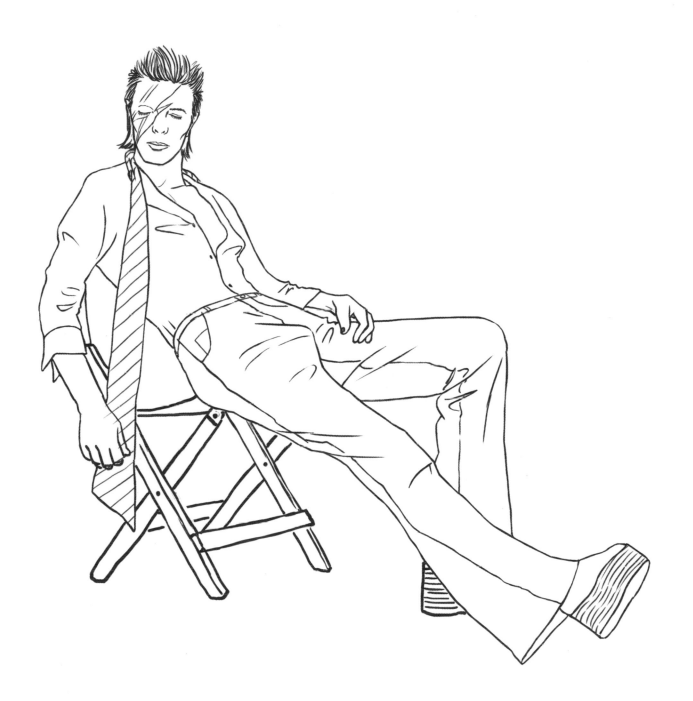

David Bowie
1947–2016